*Blake's*
*Songs of Innocence*
*&*
*of Experience*

WILLIAM BLAKE

# *Songs of Innocence*
# *&*
# *of Experience*

*Introduction by*
RICHARD HOLMES

# Introduction

William Blake was born in Soho, London, in 1757; and at the age of eight saw 'a tree filled with angels' on Peckham Rye, their bright wings 'bespangling every bough like stars'. His visionary gifts, as a painter, engraver and poet, never left him; and when he died, in a two-room garret in Fountain Court, Strand, in 1827, he was singing.

His poetic powers are most fully demonstrated in his *Songs of Innocence and of Experience*, published in 1794 and now the most justly famous of all his works, although less than thirty copies are known to have been sold in his lifetime. Wordsworth thought he was insane; Coleridge – who visited him in Fountain Court – thought he was a genius; and the world has remained somewhat divided ever since.

The *Songs* combine extreme simplicity of form with complex and mysterious meanings. To begin to understand them, it is helpful to know something of the enigmatic man who described himself as 'Author & Printer W Blake' on their title-page. Blake's father was a hosier, and all his life Blake supported himself as a small, independent craftsman-printer and illustrator. He was apprenticed to an engraver in Covent Garden, began exhibiting paintings at the Royal Academy when twenty-three, and two years later married Catherine Boucher, the beautiful young daughter of a market-gardener, whom he taught to read, mix paint and prepare plates. Her small, undulating figure seems to haunt many of his drawings. The marriage was childless (a significant fact, since the *Songs* were addressed to children), but very happy; and despite periods of poverty

and depression the household attracted many friends and later 'disciples', including the painter Samuel Palmer.

At Lambeth, where many of the *Songs* were composed, Blake was once discovered in his little back-garden, sitting naked in the sun under a tree with Catherine, reading *Paradise Lost*. He called to the friend, 'Come in! It's only Adam and Eve, you know!' Another friend of later days, Frederick Tatham, described his visionary approach to life as something quite different from hallucinations or madness: he emphasised Blake's witty originality and strong visual and dramatic sense, and in a revealing phrase called it Blake's 'peopled Thoughts'.

One can see, even in Blake's casual letters, how he constantly perceived the world around him in symbolic form. Commiserating with his friend William Hayley on the death of Hayley's son, Blake wrote: 'May you continue to be more & more persuaded that every Mortal loss is an Immortal Gain. The Ruins of Time builds Mansions in Eternity.' Again, when moving briefly to Sussex to begin new work, Blake recorded a symbolic incident which to him indicated that the work would go well. 'Work will go on here with God speed. A roller & two harrows lie before my window. I met a plow on my first going out at my gate the first morning of my arrival, & the Plowboy said to the Plowman, "Father, the Gate is Open."'

Blake read voraciously from childhood, and began writing poetry at the age of thirteen, walking about the streets of London and going on long expeditions to the surrounding country villages (as they then were) of Marylebone, Islington and Dulwich, seeing angels working

in the hayfields. Later in life he explained his inspiration in the following way: ' "What," it will be Questioned, "when the Sun rises do you not see a round disc of fire somewhat like a Guinea?" O no, no, I see an Innumerable company of the Heavenly host crying "Holy, Holy, Holy is the Lord God almighty." I question not my Corporeal or Vegetative Eye any more than I would question a Window concerning a Sight. I look through it & not with it.'

Self-taught, energetic, passionately imaginative, Blake elaborated these visions into a 'bardic' system of symbolic knowledge, a 'prophetic' philosophy which is partly religious, partly political, and partly artistic. Influenced by the millenial hopes of the French Revolution, and the Christian mysticism of Swedenborg and Jacob Boehme, Blake rebelled against all the institutions of Church and State. He challenged conventional ideas of education and sexual morality, and promulgated a libertarian view of the world in which 'Everything that lives is Holy'.

All these elements, both brilliantly original and alarmingly eccentric, are displayed in the *Songs*. It is a typical Blakean device that such profoundly strange and subversive ideas should be contained in a work purportedly addressed to children, and that 'Every child may joy to hear'. T. S. Eliot said that Blake's philosophy 'resembles an ingenuous piece of home-made furniture'; and it is true that the *Songs* with their coloured 'illuminations' have a quality that one might associate with kitchen-top publishing, open sandals and elderberry wine. But as one reads and studies them, they gradually seize upon the imagination, with something that is both majestic and almost fearful in its power.

Blake was a gentle, kindly, generous man; but never a peaceful or conventional one. Frederick Tatham observed how his broad, stocky body was never still; his hair seemed to flame above his head; his eyes blazed out, startlingly wide and large; his hands always held a pen, brush or engraver, which he constantly rolled between his fingers. ('My fingers Emit sparks of fire with Expectation of my future labours,' Blake once wrote.) He would shut himself up to work for a week, or walk forty miles in a single day. Catherine, although she often helped in his studio, once said: 'I have very little of Mr Blake's company; he is always in Paradise.'

Blake's paradise was often turbulent. In 1780 he joined the Gordon Rioters to watch them burn down Newgate Gaol; in 1789 he wore a French revolutionary 'liberty cap' in the London streets; throughout the 1790s he associated with political radicals like Thomas Paine and the feminist Mary Wollstonecraft (incorporating many of their ideas into poems); in Lambeth he frequently got into street-brawls when intervening in incidents of cruelty to women or children; and in 1803 he was charged with sedition and assault at Chichester, after throwing a soldier out of his garden (a symbolic gesture if ever there was one). Many of these incidents seem indirectly reflected in the *Songs*, together with the more arcadian side of his life with Catherine. They show that Blake was also a loving man, sensitive to every kind of callousness and injustice in the world. Both that love and that turbulence profoundly shape the restless, inspired, mysterious spirit of the *Songs*.

In literary terms, Blake conceived the *Songs* in a popular genre of illustrated children's books and hymnals, which had a highly conventional eighteenth-century tradition behind it, in works such as Isaac Watts's *Divine Songs* (1715), Mrs Anna Barbaulds's *Hymns in Prose for Children* (1781) and Mary Wollstonecraft's *Original Stories from Real Life* (1791), which Blake himself engraved.

Part One, *Songs of Innocence*, largely conforms to this tradition, set in a sunlit, pastoral world of nursery, garden and village-green. Its central ideas are those of joy, comfort, tenderness and parental or divine security; though not exclusively so. Part Two, *Songs of Experience*, largely subverts the tradition, set in a darker, more dreamlike version of the same landscape, with nightmare intimations, glimpses of forests and shadowy city streets, a sense of twilight and nightfall, and menacing animal and insect shapes. Here the central ideas are those of anger, jealousy, anxiety, cruelty, injustice and an overwhelming protest against the unhappiness in the world. Though again, not exclusively or hopelessly so. Both parts draw on a vivid, hard-edged repertory of biblical and nursery book images – Shepherd, Mother, Nurse, Lamb, Rose, Lily, Bird, Pebble, Lion, Tiger, Fly – which Blake deploys with increasing skill and sophistication.

Throughout, Blake uses arrestingly musical verse-forms: it is thought that he set several to his own tunes, though no scores have survived. They resonate with popular eighteenth-century lyric sounds: street ballads, dance tunes, psalm settings, lullabies, game songs, drinking songs and street-sellers' cries. One result of this is that they are

among the easiest poems to memorise in the English language, written in a voice that seems to rise out of some universal folklore and folksong.

Blake's notebooks – particularly the Rossetti Manuscript – show that he worked on the poems for nearly ten years between 1784 and 1793. He designed, lettered, engraved, printed and water-coloured each plate individually, so that every copy emerges with slight differences in setting, as an individual work of art. The copy used in this edition was sold by Catherine to the Bishop of Limerick in 1830 for ten guineas (the original price was ten shillings), and eventually came into the hands of the novelist E. M. Forster, who offered it to King's College, Cambridge, on his eightieth birthday.

*Innocence* was first issued as a separate work in 1789, according to its title-page. *Innocence and Experience* as a combined work first appeared in 1794. The running-order is different in some copies, and several poems – such as 'The Little Girl Lost', 'The School Boy' and 'The Voice of the Ancient Bard' – were eventually transferred from *Innocence* to *Experience*. This printing and composition history shows Blake progressively working out his notion of the 'Two Contrary States of the Human Soul' given in the subtitle, which the two Parts explore in complex resonance and thematic opposition, to rich and brilliant effect. The darkening and intensification of the mood between the two Parts must reflect much in Blake's own inner life, his spiritual quest, and perhaps his marriage with Catherine. (It is difficult not to look for an autobiographical reading in such *Experience* poems as 'The Angel' and 'My Pretty

x

Rose Tree'.) But it also reflects a shift in mood throughout English society, from the first heady and optimistic declarations of the French Revolution in 1789, to the terror and dismay of Robespierre's tyranny and the war with France in 1792, which equally darkened the whole notion of individual rights and liberty.

The essential key to understanding the *Songs* is to see that Blake uses a children's mode to produce a wholly adult poetry. Seen as a complete cycle, the *Songs* develop a vision of human nature which questions our most fundamental ideas about love, freedom, justice, cruelty and the divine or creative Power that may be active in the universe. We live in a world that contains both the Lamb and the Tyger. The radical simplicity of verse and imagery contains a continual stream of challenging doubts, provoking ironies and ambiguous symbolism. Over the last fifty years, these have been variously interpreted by Freudian, Marxist, Neoplatonist, Buddhist, Christian Gnostic and Jungian critics, all of whom have been able to illuminate the text with their commentaries.

Similarly, Blake's illustrations, border designs and changing use of colour have attracted many art historians to reinterpret the poems with further layers of meaning. The most frequent design feature, for example, the use of a bold, coloured upright in one margin of the plate (as a tree, vine, bramble, flower-stalk or lattice), has suggested a whole range of ideas about growth, freedom, containment, fruitfulness, entanglement and menace. Blake continually breaks the conventional balance of the rectangular frame with this device, producing a more open, mobile design which may

itself contain ambiguous symbols, such as the child pluck-
ing (forbidden?) fruit in 'The Ecchoing Green' (*Innocence*)
or the caterpillar (which may become a butterfly?) in 'The
Sick Rose' (*Experience*). Again, the innocent crimson of the
flower in 'Infant Joy' is re-read through the tumescent, sexual
crimson of the Maiden Queen in 'The Angel'. The skilful
integration of poem with illustration may also suggest that
the text itself is some sort of natural growth or blossoming
out from one of Blake's visual (visionary) epiphanies, the
fruit of a different order of experience.

Blake sometimes seemed to regard the engraving pro-
cess itself, the use of acid on copper to reveal a mirror-image,
as in some way exemplary of his art. He once said that his
engraving was 'printing in the Infernal method, by corro-
sives, which in Hell are salutary and medicinal, melting
surfaces away, and displaying the Infinite which was hid'
(*The Marriage of Heaven and Hell*).

As to Blake's controlling thematic idea of 'Two
Contrary States of the Human Soul', these are not con-
ventional opposites, but something more dynamic and
mystical. The initial concept of a dynamic or reverberating
spiritual universe was probably taken from Swedenborg,
and has a long, partly occult, history in antinomian
Christian thought, which always appealed to Blake the
intellectual rebel. He also explored it epigrammatically in
*The Proverbs of Hell* (1790), many of which bear on the
*Songs*, such as the celebrated formulations: 'Joy impreg-
nates. Sorrows bring forth'; and 'Sooner murder an infant
in its cradle than nurse unacted desires'. He believed that
'Without Contraries is no Progression'.

The *Songs* do indeed have a pattern of 'contrary' or answering poems: such as 'The Lamb' (8) and 'The Tyger' (42); 'The Chimney Sweeper' (12 and 37); 'The Little Boy lost' (13 and 50); 'Holy Thursday' (19 and 33); 'Nurse's Song' (24 and 38); 'Infant Joy' (25) and 'Infant Sorrow' (48). These poems turn the same images, and even sometimes the same words (such as 'green' in 'Nurse's Song'), from states of joy and content, to those of sorrow and protest. But the Contrary States go far deeper than this.

The Contraries exist *within* the poems themselves, emerging with ever stronger force as the cycle advances. Even in *Innocence* there are strange moments of anxiety and unease. What is the meaning of 'The Blossom' (11)? Is it a mother talking to her infant at the breast, at one moment like the 'Merry Sparrow', and at the next like the 'sobbing Robin'? (And if so, why the change?) Or is it, as some Freudian critics have suggested, some mysterious parable of sexual pleasure? Or again, what exactly is the protest against the slave-trade contained in 'The Little Black Boy' (9), in which God's love seems to be an unbearable scorching heat like the tropic sun? And why does the black child have to protect the white child?

These puzzling ambiguities, or contrary energies of meaning, are greatly increased in *Experience*. The metaphysical terror of 'The Sick Rose' (39) or the grim allegories of 'Ah! Sun-Flower' and 'My Pretty Rose Tree' (43) suggest profound and disabling glimpses into realms both sexual and religious, in which the hopes of human love are dashed against the realities of Time. Yet they also suggest strange possibilities of delight and transcendence

in Eternity. 'The Tyger', for all its fire and dread, its relentless hammering out of fearful questions, also conjures up a vision of sublime creative power, an incandescent workshop in the artist's own brain, which can somehow 'frame' an entire universe, and dares to do so.

Or 'London' (46), one of Blake's greatest poems of outrage against social injustice, which transforms the sounds and images of eighteenth-century London (the river, the palace, the church, the brothel) into eternal symbols of pain and protest; yet in the very force and music of that nightmare vision ('But most thro' midnight streets I hear') asserts a poetic consciousness that knows a Contrary State, that passionately believes in an arcadian city of sunlight, freedom and joy, where 'new-born Infants' will never have to weep. In such poems Blake's visionary genius triumphs forever.

Here then is a book that, at first sight, may appear like an eccentric, childlike, naively illustrated collection of nursery home-spun verses; but which grows compellingly into one of the great works of the English Romantic imagination. It has a quality of philosophic epic more usually associated with the major poems of Milton or Wordsworth. It is remarkable that among William Blake's greatest champions have been his fellow poets from later days – among them Swinburne, Yeats, Kathleen Raine and Allen Ginsberg. His *Songs* make us re-read our own childhood and supposed maturity; and alert us again to the possibility of angels and what they may be telling us.

*Richard Holmes*

## Acknowledgements

The Folio Society is most grateful to the Provost and Scholars of King's College, Cambridge, for making their copy of the Songs available for reproduction; to the William Blake Trust and the Tate Gallery, who first published the facsimile as Volume 2 of their collected edition of the Illuminated books and who have lent us the colour separations; and to Andrew Lincoln, who edited that edition and whose transcriptions of the poems are reproduced here.

# Contents

[Combined Title-page]

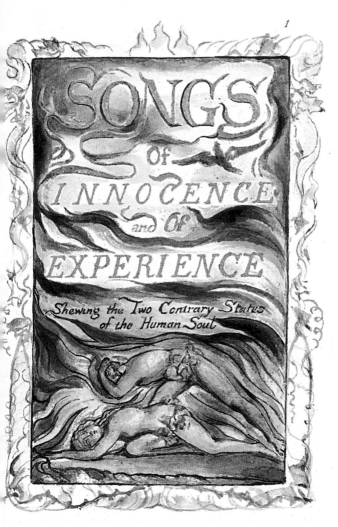

SONGS
of
INNOCENCE
and of
EXPERIENCE

Shewing the Two Contrary States
of the Human Soul

[Innocence Frontispiece]

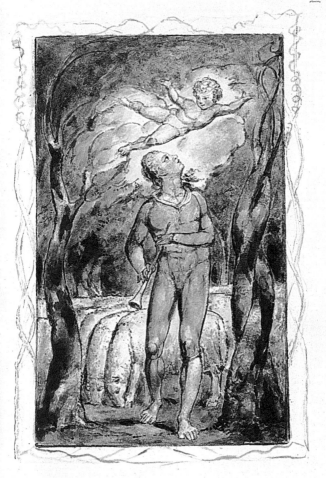

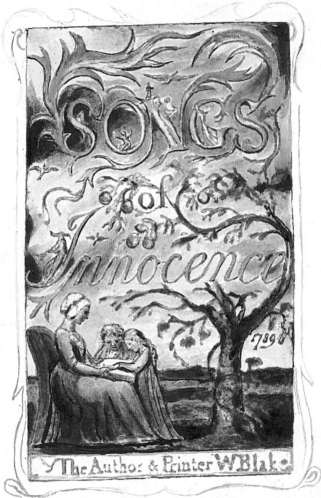

SONGS of Innocence

1789

The Author & Printer W Blake

*Introduction*

Piping down the valleys wild
Piping songs of pleasant glee
On a cloud I saw a child.
And he laughing said to me.

Pipe a song about a Lamb:
So I piped with merry chear,
Piper pipe that song again—
So I piped, he wept to hear.

Drop thy pipe thy happy pipe
Sing thy songs of happy chear,
So I sung the same again
While he wept with joy to hear

Piper sit thee down and write
In a book that all may read—
So he vanish'd from my sight
And I pluck'd a hollow reed

And I made a rural pen,
And I stain'd the water clear,
And I wrote my happy songs,
Every child may joy to hear.

# Introduction

Piping down the valleys wild
Piping songs of pleasant glee
On a cloud I saw a child.
And he laughing said to me.

Pipe a song about a Lamb:
So I piped with merry chear,
Piper pipe that song again—
So I piped, he wept to hear.

Drop thy pipe thy happy pipe
Sing thy songs of happy chear,
So I sung the same again,
While he wept with joy to hear.

Piper sit thee down and write
In a book that all may read—
So he vanish'd from my sight.
And I pluck'd a hollow reed.

And I made a rural pen,
And I stain'd the water clear,
And I wrote my happy songs
Every child may joy to hear.

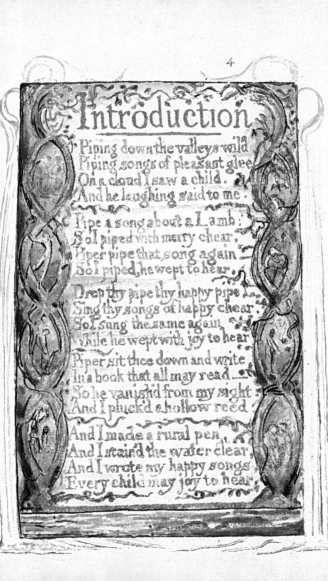

*The Shepherd.*

How sweet is the Shepherds sweet lot,
From the morn to the evening he strays:
He shall follow his sheep all the day
And his tongue shall be filled with praise.

For he hears the lambs innocent call.
And he hears the ewes tender reply,
He is watchful while they are in peace,
For they know when their Shepherd is nigh.

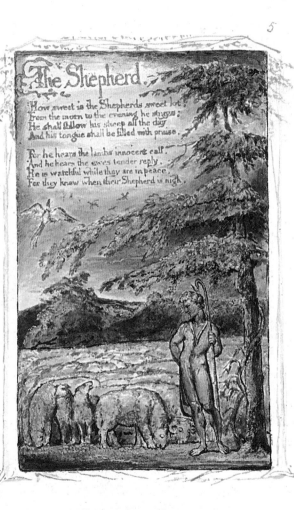

# The Shepherd.

How sweet is the Shepherds sweet lot,
from the morn to the evening he strays;
He shall follow his sheep all the day
And his tongue shall be filled with praise.

For he hears the lambs innocent call,
And he hears the ewes tender reply,
He is watchful while they are in peace,
For they know when their Shepherd is nigh.

*The Ecchoing Green*

The Sun does arise,
And make happy the skies.
The merry bells ring,
To welcome the Spring.
The sky-lark and thrush,
The birds of the bush,
Sing louder around,
To the bells chearful sound.
While our sports shall be seen
On the Ecchoing Green.

Old John with white hair
Does laugh away care,
Sitting under the oak
Among the old folk.

*They*

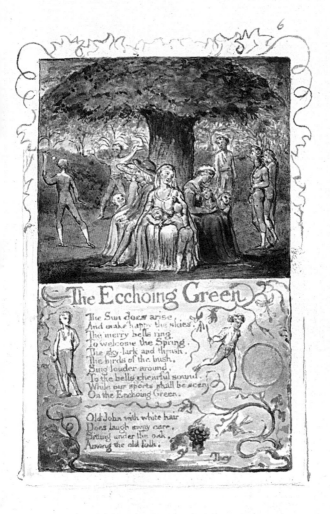

# The Ecchoing Green

The Sun does arise
And make happy the skies.
The merry bells ring
To welcome the Spring.
The sky-lark and thrush,
The birds of the bush,
Sing louder around,
To the bells cheerful sound.
While our sports shall be seen
On the Ecchoing Green.

Old John with white hair
Does laugh away care,
Sitting under the oak,
Among the old folk,
They

They laugh at our play,
And soon they all say,
Such such were the joys.
When we all girls & boys.
In our youth time were seen,
On the Ecchoing Green.

Till the little ones weary
No more can be merry
The sun does descend,
And our sports have an end:
Round the laps of their mothers.
Many sisters and brothers,
Like birds in their nest.
Are ready for rest;
And sport no more seen,
On the darkening Green.

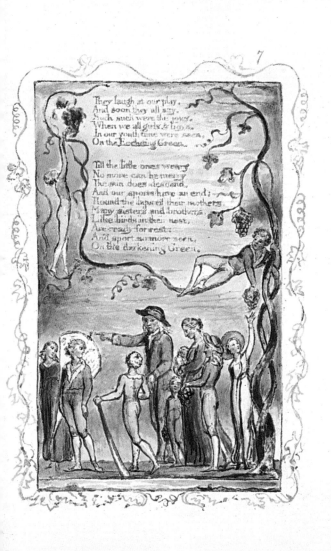

They laugh at our play,
And soon they all say,
Such such were the joys,
When we all girls & boys,
In our youth time were seen,
On the Ecchoing Green.

Till the little ones weary
No more can be merry
The sun does descend,
And our sports have an end:
Round the laps of their mothers
Many sisters and brothers
Like birds in their nest,
Are ready for rest:
And sport no more seen,
On the darkening Green.

*The Lamb*

Little Lamb who made thee
Dost thou know who made thee
Gave thee life & bid thee feed.
By the stream & o'er the mead;
Gave thee clothing of delight.
Softest clothing wooly bright;
Gave thee such a tender voice.
Making all the vales rejoice:
Little Lamb who made thee
Dost thou know who made thee

Little Lamb I'll tell thee,
Little Lamb Ill tell thee;
He is called by thy name,
For he calls himself a Lamb:
He is meek & he is mild,
He became a little child:
I a child & thou a lamb,
We are called by his name,
Little Lamb God bless thee,
Little Lamb God bless thee.

# The Lamb

Little Lamb who made thee
Dost thou know who made thee
Gave thee life & bid thee feed.
By the stream & o'er the mead;
Gave thee clothing of delight,
Softest clothing wooly bright;
Gave thee such a tender voice,
Making all the vales rejoice:
Little Lamb who made thee
Dost thou know who made thee

Little Lamb I'll tell thee,
Little Lamb I'll tell thee;
He is called by thy name,
For he calls himself a Lamb:
He is meek & he is mild,
He became a little child:
I a child & thou a lamb,
We are called by his name.
Little Lamb God bless thee.
Little Lamb God bless thee.

*The Little Black Boy*

My mother bore me in the southern wild,
And I am black, but O! my soul is white.
White as an angel is the English child:
But I am black as if bereav'd of light.

My mother taught me underneath a tree
And sitting down before the heat of day.
She took me on her lap and kissed me,
And pointing to the east began to say.

Look on the rising sun: there God does live
And gives his light. and gives his heat away.
And flowers and trees and beasts and men recieve
Comfort in morning joy in the noon day.

And we are put on earth a little space. .
That we may learn to bear the beams of love.
And these black bodies and this sun-burnt face
Is but a cloud, and like a shady grove.

*For*

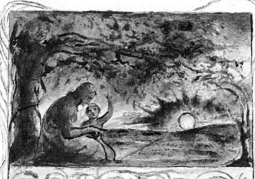

# The Little Black Boy

My mother bore me in the southern wild,
And I am black, but O! my soul is white.
White as an angel is the English child:
But I am black as if bereav'd of light.

My mother taught me underneath a tree
And sitting down before the heat of day,
She took me on her lap and kissed me,
And pointing to the east began to say.

Look on the rising sun: there God does live
And gives his light, and gives his heat away.
And flowers and trees and beasts and men recieve
Comfort in morning joy in the noon day.

And we are put on earth a little space,
That we may learn to bear the beams of love,
And these black bodies and this sunburnt face
Is but a cloud, and like a shady grove.

For

For when our souls have learn'd the heat to bear
The cloud will vanish we shall hear his voice.
Saying: come out from the grove my love & care.
And round my golden tent like lambs rejoice.

Thus did my mother say and kissed me.
And thus I say to little English boy.
When I from black and he from white cloud free,
And round the tent of God like lambs we joy:

Ill shade him from the heat till he can bear,
To lean in joy upon our fathers knee.
And then I'll stand and stroke his silver hair,
And be like him and he will then love me.

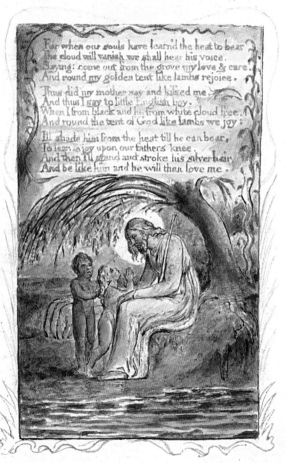

For when our souls have learn'd the heat to bear
The cloud will vanish we shall hear his voice.
Saying: come out from the grove my love & care.
And round my golden tent like lambs rejoice.

Thus did my mother say and kissed me
And thus I say to little English boy.
When I from black and he from white cloud free,
And round the tent of God like lambs we joy:

Ill shade him from the heat till he can bear,
To lean in joy upon our fathers knee.
And then Ill stand and stroke his silver hair
And be like him and he will then love me.

*The Blossom.*

Merry Merry Sparrow
Under leaves so green
A happy Blossom
Sees you swift as arrow
Seek your cradle narrow
Near my Bosom.

Pretty Pretty Robin
Under leaves so green
A happy Blossom
Hears you sobbing sobbing
Pretty Pretty Robin
Near my Bosom.

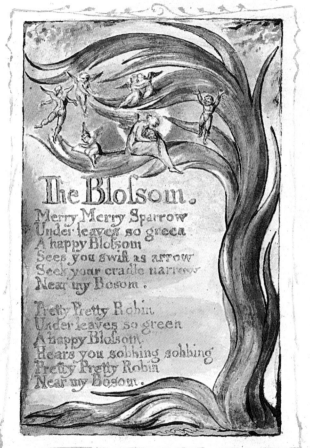

# The Blossom.

Merry, Merry Sparrow
Under leaves so green
A happy Blossom
Sees you swift as arrow
Seek your cradle narrow
Near my Bosom.

Pretty Pretty Robin
Under leaves so green
A happy Blossom
Hears you sobbing sobbing
Pretty Pretty Robin
Near my Bosom.

*The Chimney Sweeper*

When my mother died I was very young,
And my father sold me while yet my tongue,
Could scarcely cry weep weep weep weep,
So your chimneys I sweep & in soot I sleep.
Theres little Tom Dacre. who cried when his head
That curl'd like a lambs back, was shav'd, so I said.
Hush Tom never mind it, for when your head's bare,
You know that the soot cannot spoil your white hair
And so he was quiet. & that very night.
As Tom was a sleeping he had such a sight,
That thousands of sweepers Dick, Joe, Ned & Jack
Were all of them lock'd up in coffins of black,
And by came an Angel who had a bright key
And he open'd the coffins & set them all free.
Then down a green plain leaping laughing they run
And wash in a river and shine in the Sun.
Then naked & white, all their bags left behind.
They rise upon clouds, and sport in the wind.
And the Angel told Tom, if he'd be a good boy,
He'd have God for his father & never want joy.
And so Tom awoke and we rose in the dark
And got with our bags & our brushes to work.
Tho' the morning was cold, Tom was happy & warm
So if all do their duty, they need not fear harm.

# The Chimney Sweeper

When my mother died I was very young,
And my father sold me while yet my tongue,
Could scarcely cry weep weep weep weep.
So your chimneys I sweep & in soot I sleep.

Theres little Tom Dacre, who cried when his head
That curld like a lambs back, was shav'd, so I said.
Hush Tom never mind it, for when your heads bare,
You know that the soot cannot spoil your white hair

And so he was quiet, & that very night,
As Tom was a sleeping he had such a sight,
That thousands of sweepers Dick, Joe, Ned & Jack
Were all of them lock'd up in coffins of black,

And by came an Angel who had a bright key,
And he open'd the coffins & set them all free.
Then down a green plain leaping laughing they run
And wash in a river and shine in the Sun.

Then naked & white, all their bags left behind,
They rise upon clouds, and sport in the wind.
And the Angel told Tom if he'd be a good boy,
He'd have God for his father & never want joy.

And so Tom awoke and we rose in the dark
And got with our bags & our brushes to work.
Tho' the morning was cold, Tom was happy & warm,
So if all do their duty, they need not fear harm.

*The Little Boy lost*

Father, father, where are you going
O do not walk so fast.
Speak father, speak to your little boy
Or else I shall be lost,

The night was dark no father was there
The child was wet with dew.
The mire was deep, & the child did weep
And away the vapour flew

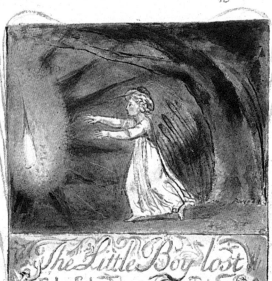

# The Little Boy lost

Father, father, where are you going
  O do not walk so fast.
Speak father, speak to your little boy
  Or else I shall be lost,

The night was dark no father was there
The child was wet with dew.
The mire was deep, & the child did weep
And away the vapour flew.

*The Little Boy found*

The little boy lost in the lonely fen,
Led by the wand'ring light,
Began to cry, but God ever nigh,
Appeard like his father in white.

He kissed the child & by the hand led
And to his mother brought,
Who in sorrow pale. thro' the lonely dale
Her little boy weeping sought.

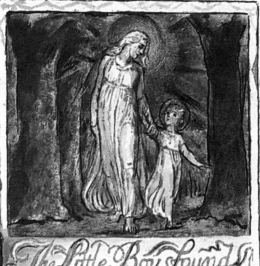

# The Little Boy found

The little boy lost in the lonely fen,
Led by the wandring light,
Began to cry, but God ever nigh,
Appeard like his father in white.

He kissed the child & by the hand led
And to his mother brought,
Who in sorrow pale, thro' the lonely dale
Her little boy weeping sought.

*Laughing Song,*

When the green woods laugh with the voice of joy
And the dimpling stream runs laughing by,
When the air does laugh with our merry wit,
And the green hill laughs with the noise of it.

When the meadows laugh with lively green
And the grasshopper laughs in the merry scene.
When Mary and Susan and Emily.
With their sweet round mouths sing Ha, Ha, He.

When the painted birds laugh in the shade
Where our table with cherries and nuts is spre[ad]
Come live & be merry and join with me,
To sing the sweet chorus of Ha, Ha, He.

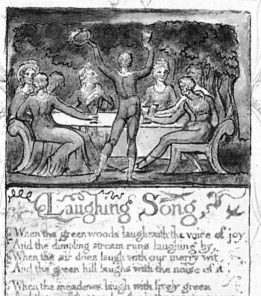

# Laughing Song.

When the green woods laugh with the voice of joy
And the dimpling stream runs laughing by,
When the air does laugh with our merry wit,
And the green hill laughs with the noise of it.

When the meadows laugh with lively green
And the grasshopper laughs in the merry scene.
When Mary and Susan and Emily.
With their sweet round mouths sing Ha, Ha, He.

When the painted birds laugh in the shade
Where our table with cherries and nuts is spread.
Come live & be merry and join with me.
To sing the sweet chorus of Ha, Ha, He.

## A CRADLE SONG

Sweet dreams form a shade,
O'er my lovely infants head.
Sweet dreams of pleasant streams,
By happy silent moony beams

Sweet sleep with soft down.
Weave thy brows an infant crown.
Sweet sleep Angel mild,
Hover o'er my happy child.

Sweet smiles in the night,
Hover over my delight.
Sweet smiles Mothers smiles
All the livelong night beguiles.

Sweet moans, dovelike sighs,
Chase not slumber from thy eyes,
Sweet moans. sweeter smiles,
All the dovelike moans beguiles.

Sleep sleep happy child,
All creation slept and smil'd.
Sleep sleep, happy sleep.
While o'er thee thy mother weep

Sweet babe in thy face,
Holy image I can trace.
Sweet babe once like thee.
Thy maker lay and wept for me

*Wept*

# A CRADLE SONG

Sweet dreams form a shade.
Oer my lovely infants head.
Sweet dreams of pleasant streams.
By happy silent moony beams

Sweet sleep with soft down.
Weave thy brows an infant crown.
Sweet sleep Angel mild.
Hover oer my happy child.

Sweet smiles in the night.
Hover over my delight.
Sweet smiles Mothers smiles
All the livelong night beguiles.

Sweet moans, dovelike sighs.
Chase not slumber from thy eyes.
Sweet moans, sweeter smiles.
All the dovelike moans beguiles.

Sleep sleep happy child.
All creation slept and smild.
Sleep sleep happy sleep.
While oer thee thy mother weep

Sweet babe in thy face.
Holy image I can trace.
Sweet babe once like thee.
Thy maker lay and wept for me

Wept for me for thee for all,
When he was an infant small.
Thou his image ever see.
Heavenly face that smiles on thee,

Smiles on thee on me on all,
Who became an infant small,
Infant smiles are his own smiles,
Heaven & earth to peace beguiles.

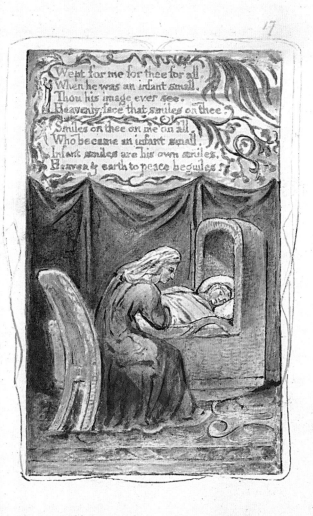

Wept for me for thee for all
When he was an infant small.
Thou his image ever see.
Heavenly face that smiles on thee.

Smiles on thee on me on all
Who became an infant small.
Infant smiles are his own smiles.
Heaven & earth to peace beguiles

*The Divine Image.*

To Mercy Pity Peace and Love.
All pray in their distress:
And to these virtues of delight
Return their thankfulness.

For Mercy Pity Peace and Love,
Is God our father dear:
And Mercy Pity Peace and Love,
Is Man his child and care.

For Mercy has a human heart
Pity, a human face:
And Love, the human form divine,
And Peace, the human dress.

Then every man of every clime,
That prays in his distress,
Prays to the human form divine
Love Mercy Pity Peace,

And all must love the human form.
In heathen, turk or jew,
Where Mercy, Love & Pity dwell,
There God is dwelling too.

18

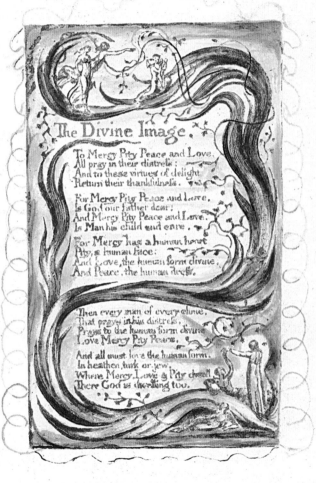

# The Divine Image.

To Mercy Pity Peace and Love,
All pray in their distress:
And to these virtues of delight
Return their thankfulness.

For Mercy Pity Peace and Love,
Is God our father dear:
And Mercy Pity Peace and Love,
Is Man his child and care.

For Mercy has a human heart
Pity, a human face:
And Love, the human form divine,
And Peace, the human dress.

Then every man of every clime,
That prays in his distress,
Prays to the human form divine
Love Mercy Pity Peace.

And all must love the human form,
In heathen, turk or jew.
Where Mercy, Love & Pity dwell,
There God is dwelling too.

## HOLY THURSDAY

Twas on a Holy Thursday their innocent faces clean
The children walking two & two in red & blue & gre[en]
Grey headed beadles walkd before with wands as white as snow
Till into the high dome of Pauls they like Thames waters flow

O what a multitude they seemd these flowers of London town
Seated in companies they sit with radiance all their own
The hum of multitudes was there but multitudes of lambs
Thousands of little boys & girls raising their innocent hands

Now like a mighty wind they raise to heaven the voice of song
Or like harmonious thunderings the seats of heaven among
Beneath them sit the aged men wise guardians of the poor
Then cherish pity, lest you drive an angel from your door

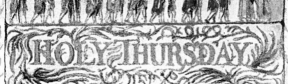

# HOLY THURSDAY

'Twas on a Holy Thursday their innocent faces clean
The children walking two & two in red & blue & green
Grey headed beadles walkd before with wands as white as snow
Till into the high dome of Pauls they like Thames waters flow

O what a multitude they seemd these flowers of London town
Seated in companies they sit with radiance all their own
The hum of multitudes was there but multitudes of lambs
Thousands of little boys & girls raising their innocent hands

Now like a mighty wind they raise to heaven the voice of song
Or like harmonious thunderings the seats of heaven among
Beneath them sit the aged men wise guardians of the poor
Then cherish pity, lest you drive an angel from your door

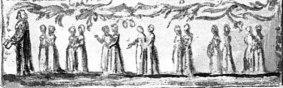

*Night*

The sun descending in the west.
The evening star does shine.
The birds are silent in their nest,
And I must seek for mine,
The moon like a flower,
In heavens high bower;
With silent delight,
Sits and smiles on the night.

Farewell green fields and happy groves,
Where flocks have took delight;
Where lambs have nibbled, silent moves
The feet of angels bright;
Unseen they pour blessing,
And joy without ceasing,
On each bud and blossom,
And each sleeping bosom.

They look in every thoughtless nest
Where birds are coverd warm;
They visit caves of every beast,
To keep them all from harm;
If they see any weeping,
That should have been sleeping
They pour sleep on their head
And sit down by their bed.

*When*

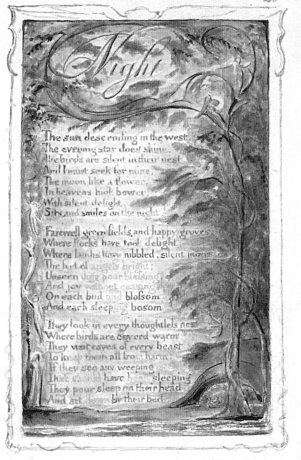

# Night

The sun descending in the west,
The evening star does shine;
The birds are silent in their nest,
And I must seek for mine,
The moon like a flower,
In heavens high bower
With silent delight,
Sits and smiles on the night.

Farewell green fields and happy groves,
Where flocks have took delight,
Where lambs have nibbled, silent moves
The feet of angels bright;
Unseen they pour blessing,
And joy without ceasing,
On each bud and blossom,
And each sleeping bosom.

They look in every thoughtless nest,
Where birds are coverd warm;
They visit caves of every beast,
To keep them all from harm.
If they see any weeping
That should have been sleeping
They pour sleep on their head
And sit down by their bed.

When wolves and tygers howl for prey
They pitying stand and weep;
Seeking to drive their thirst away,
And keep them from the sheep.
But if they rush dreadful;
The angels most heedful,
Recieve each mild spirit.
New worlds to inherit.

And there the lions ruddy eyes,
Shall flow with tears of gold;
And pitying the tender cries,
And walking round the fold:
Saying: wrath by his meekness
And by his health, sickness.
Is driven away,
From our immortal day.

And now beside thee bleating lamb.
I can lie down and sleep;
Or think on him who bore thy name.
Grase after thee and weep.
For wash'd in lifes river.
My bright mane for ever.
Shall shine like the gold.
As I guard o'er the fold.

When wolves and tygers howl for prey
They pitying stand and weep;
Seeking to drive their thirst away,
And keep them from the sheep.
But if they rush dreadful;
The angels most heedful,
Recieve each mild spirit,
New worlds to inherit.

And there the lions ruddy eyes,
Shall flow with tears of gold:
And pitying the tender cries,
And walking round the fold:
Saying; wrath by his meekness
And by his health, sickness,
Is driven away.
From our immortal day.

And now beside thee bleating lamb,
I can lie down and sleep;
Or think on him who bore thy name,
Graze after thee and weep.
For wash'd in lifes river,
My bright mane for ever,
Shall shine like the gold,
As I guard o'er the fold.

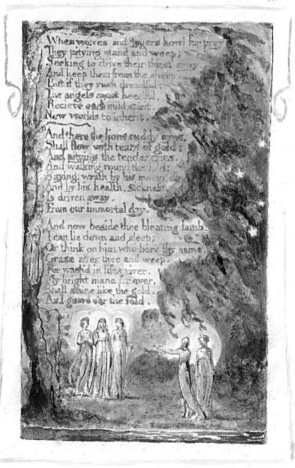

*Spring*

Sound the Flute!
Now it's mute.
Birds delight
Day and Night,
Nightingale
In the dale
Lark in Sky
Merrily
Merrily Merrily to welcome in the
Year

Little Boy
Full of joy,

*Little*

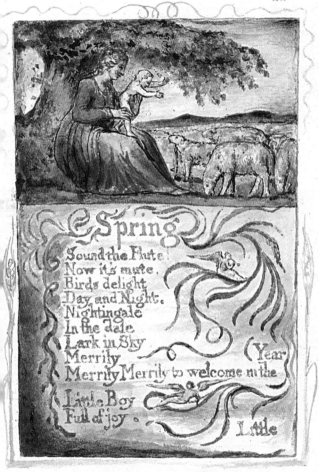

# Spring

Sound the Flute!
Now it's mute.
Birds delight
Day and Night.
Nightingale
In the dale
Lark in Sky
Merrily
Merrily Merrily to welcome in the Year

Little Boy
Full of joy.

Little

Little Girl
Sweet and small,
Cock does crow
So do you.
Merry voice
Infant noise
Merrily Merrily to welcome in the Year

Little Lamb
Here I am.
Come and lick
My white neck.
Let me pull
Your soft Wool.
Let me kiss
Your soft face
Merrily Merrily we welcome in the Year

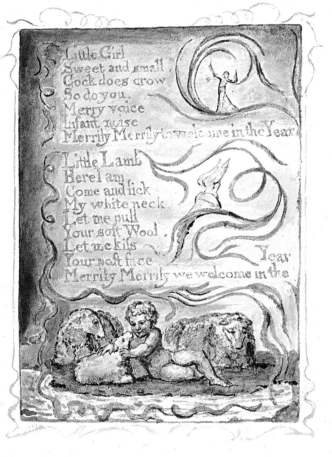

23

Little Girl
Sweet and small
Cock does crow
So do you.
Merry voice
Infant noise
Merrily Merrily to welcome in the Year

Little Lamb
Here I am,
Come and lick
My white neck
Let me pull
Your soft Wool.
Let me kiss
Your soft face
Merrily Merrily we welcome in the Year

*Nurse's Song*

When the voices of children are heard on the green
And laughing is heard on the hill,
My heart is at rest within my breast
And everything else is still

Then come home my children the sun is gone down
And the dews of night arise
Come come leave off play, and let us away
Till the morning appears in the skies

No no let us play, for it is yet day
And we cannot go to sleep
Besides in the sky, the little birds fly
And the hills are all coverd with sheep

Well well go & play till the light fades away
And then go home to bed
The little ones leaped & shouted & laugh'd
And all the hills ecchoed

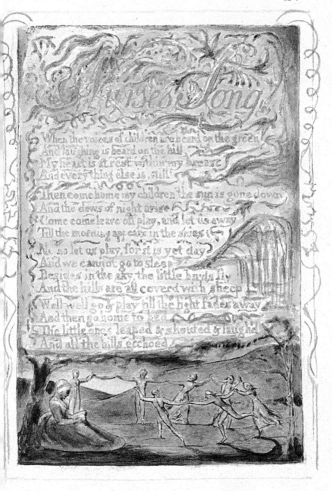

# Nurses Song

When the voices of children are heard on the green
And laughing is heard on the hill
My heart is at rest within my breast
And every thing else is still

Then come home my children the sun is gone down
And the dews of night arise
Come come leave off play, and let us away
Till the morning appears in the skies

No no let us play, for it is yet day
And we cannot go to sleep
Besides in the sky, the little birds fly
And the hills are all covered with sheep

Well well go & play till the light fades away
And then go home to bed
The little ones leaped & shouted & laughd
And all the hills ecchoed

*Infant Joy*

I have no name
I am but two days old.—
What shall I call thee?
I happy am
Joy is my name.—
Sweet joy befall thee!

Pretty joy!
Sweet joy but two days old.
Sweet joy I call thee;
Thou dost smile,
I sing the while
Sweet joy befall thee.

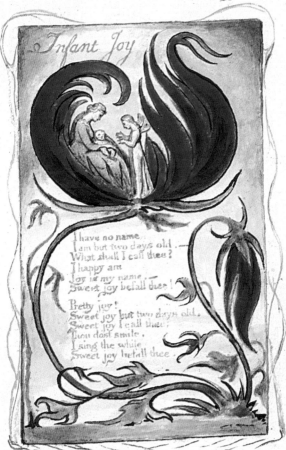

Infant Joy

I have no name.
I am but two days old.—
What shall I call thee?
I happy am
Joy is my name.—
Sweet joy befall thee!

Pretty joy!
Sweet joy but two days old.
Sweet joy I call thee:
Thou dost smile.
I sing the while.
Sweet joy befall thee.

*A Dream*

Once a dream did weave a shade,
O'er my Angel-guarded bed.
That an Emmet lost it's way
Where on grass methought I lay.

Troubled wilderd and forlorn
Dark benighted travel-worn,
Over many a tangled spray,
All heart-broke I heard her say.

O my children! do they cry,
Do they hear their father sigh.
Now they look abroad to see,
Now return and weep for me.

Pitying I drop'd a tear;
But I saw a glow-worm near:
Who replied. What wailing wight
Calls the watchman of the night.

I am set to light the ground,
While the beetle goes his round:
Follow now the beetles hum,
Little wanderer hie thee home.

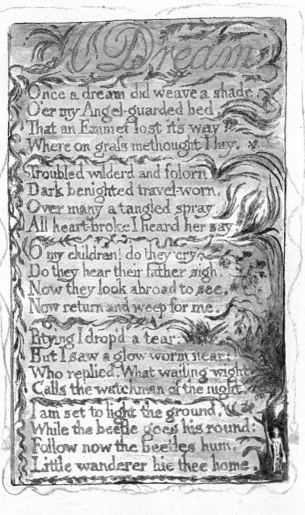

# A Dream

Once a dream did weave a shade.
O'er my Angel-guarded bed,
That an Emmet lost it's way
Where on grass methought I lay.

Troubled wilderd and folorn
Dark benighted travel-worn.
Over many a tangled spray
All heart-broke I heard her say

O my children! do they cry
Do they hear their father sigh.
Now they look abroad to see,
Now return and weep for me.

Pitying I dropd a tear:
But I saw a glow-worm near:
Who replied. What wailing wight
Calls the watchman of the night.

I am set to light the ground,
While the beetle goes his round:
Follow now the beetles hum,
Little wanderer hie thee home.

*On Anothers Sorrow*

Can I see anothers woe,
And not be in sorrow too.
Can I see anothers grief,
And not seek for kind relief.

Can I see a falling tear.
And not feel my sorrows share,
Can a father see his child,
Weep, nor be with sorrow fill'd.

Can a mother sit and hear.
An infant groan an infant fear—
No no never can it be,
Never never can it be.

And can he who smiles on all
Hear the wren with sorrows small.
Hear the small birds grief & care
Hear the woes that infants bear—

And not sit beside the nest
Pouring pity in their breast.
And not sit the cradle near
Weeping tear on infants tear.

And not sit both night & day.
Wiping all our tears away.
O! no never can it be.
Never never can it be.

He doth give his joy to all,
He becomes an infant small,
He becomes a man of woe
He doth feel the sorrow too.

Think not. thou canst sigh a sigh,
And thy maker is not by.
Think not, thou canst weep a tear,
And thy maker is not near.

O! he gives to us his joy.
That our grief he may destroy
Till our grief is fled & gone
He doth sit by us and moan

27

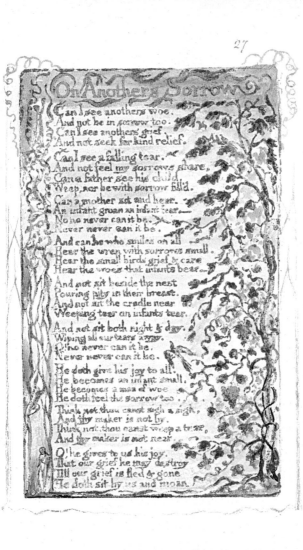

# On Anothers Sorrow

Can I see anothers woe,
And not be in sorrow too.
Can I see anothers grief,
And not seek for kind relief.

Can I see a falling tear.
And not feel my sorrows share,
Can a father see his child,
Weep, nor be with sorrow filld.

Can a mother sit and hear,
An infant groan an infant fear—
No no never can it be.
Never never can it be.

And can he who smiles on all
Hear the wren with sorrows small,
Hear the small birds grief & care
Hear the woes that infants bear—

And not sit beside the nest
Pouring pity in their breast.
And not sit the cradle near
Weeping tear on infants tear.

And not sit both night & day,
Wiping all our tears away.
O! no never can it be.
Never never can it be.

He doth give his joy to all.
He becomes an infant small.
He becomes a man of woe
He doth feel the sorrow too.

Think not thou canst sigh a sigh,
And thy maker is not by.
Think not thou canst weep a tear,
And thy maker is not near.

O! he gives to us his joy,
That our grief he may destroy
Till our grief is fled & gone
He doth sit by us and moan.

[Experience Frontispiece]

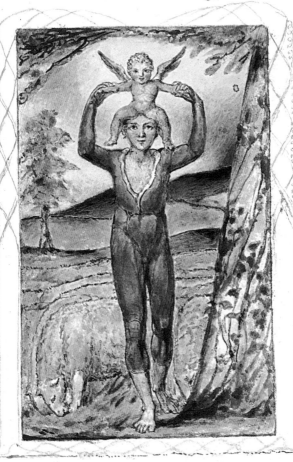

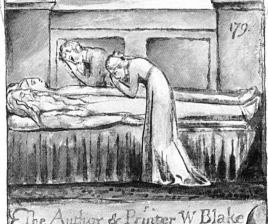

# SONGS
# EXPERIENCE

The Author & Printer W Blake

*Introduction.*

Hear the voice of the Bard!
Who Present, Past, & Future sees
Whose ears have heard,
The Holy Word,
That walk'd among the ancient trees.

Calling the lapsed Soul
And weeping in the evening dew;
That might controll.
The starry pole;
And fallen fallen light renew!

O Earth O Earth return!
Arise from out the dewy grass;
Night is worn,
And the morn
Rises from the slumberous mass.

Turn away no more:
Why wilt thou turn away
The starry floor
The watry shore
Is givn thee till the break of day.

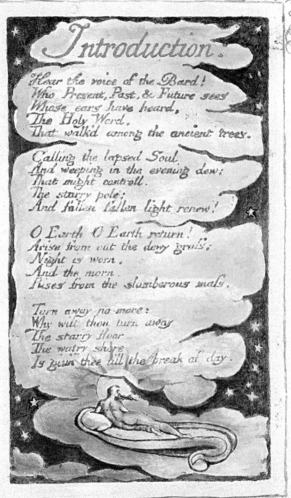

# Introduction.

Hear the voice of the Bard!
Who Present, Past, & Future sees
Whose ears have heard,
The Holy Word,
That walk'd among the ancient trees.

Calling the lapsed Soul
And weeping in the evening dew:
That might controll,
The starry pole;
And fallen fallen light renew!

O Earth O Earth return!
Arise from out the dewy grass;
Night is worn,
And the morn
Rises from the slumberous mass.

Turn away no more:
Why wilt thou turn away
The starry floor
The watry shore
Is giv'n thee till the break of day.

*EARTH's Answer*

Earth raisd up her head.
From the darkness dread & drear.
Her light fled:
Stony dread!
And her locks cover'd with grey despair.

Prison'd on watry shore
Starry Jealousy does keep my den
Cold and hoar
Weeping o'er
I hear the father of the ancient men

Selfish father of men
Cruel jealous selfish fear
Can delight
Chain'd in night
The virgins of youth and morning bear.

Does spring hide its joy
When buds and blossoms grow?
Does the sower?
Sow by night?
Or the plowman in darkness plow?

Break this heavy chain.
That does freeze my bones around
Selfish! vain!
Eternal bane!
That free Love with bondage bound.

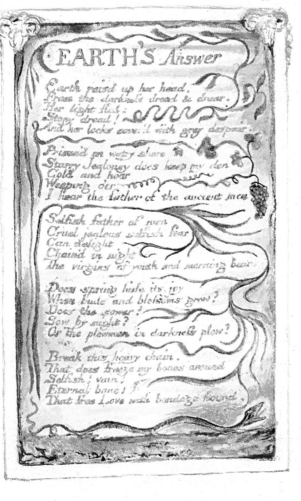

# EARTH'S *Answer*

Earth raised up her head,
From the darkness dread & drear.
Her light fled:
Stony dread!
And her locks cover'd with grey despair.

Prison'd on watry shore
Starry Jealousy does keep my den
Cold and hoar
Weeping o'er
I hear the father of the ancient men

Selfish father of men
Cruel jealous selfish fear
Can delight
Chain'd in night
The virgins of youth and morning bear.

Does spring hide its joy
When buds and blossoms grow?
Does the sower!
Sow by night?
Or the plowman in darkness plow?

Break this heavy chain,
That does freeze my bones around
Selfish! vain!
Eternal bane!
That free Love with bondage bound.

*The CLOD & The PEBBLE*

Love seeketh not Itself to please.
Nor for itself hath any care;
But for another gives its ease.
And builds a Heaven in Hells despair.

    So sung a little Clod of Clay,
    Trodden with the cattles feet;
    But a Pebble of the brook.
    Warbled out these metres meet.

Love seeketh only Self to please,
To bind another to Its delight;
Joys in anothers loss of ease.
And builds a Hell in Heavens despite.

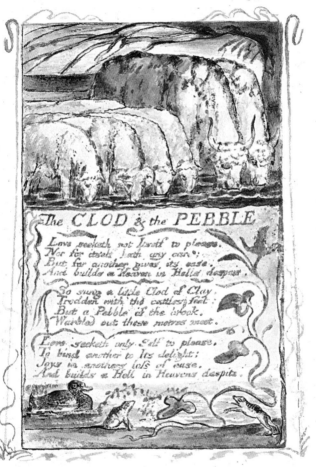

# The CLOD & the PEBBLE

Love seeketh not Itself to please,
Nor for itself hath any care;
But for another gives its ease,
And builds a Heaven in Hells despair.

So sung a little Clod of Clay
Trodden with the cattles feet;
But a Pebble of the brook,
Warbled out these metres meet.

Love seeketh only Self to please,
To bind another to Its delight;
Joys in anothers loss of ease,
And builds a Hell in Heavens despite.

## HOLY THURSDAY

Is this a holy thing to see.
In a rich and fruitful land.
Babes reducd to misery.
Fed with cold and usurous hand?

Is that trembling cry a song?
Can it be a song of joy?
And so many children poor?
It is a land of poverty!

And their sun does never shine.
And their fields are bleak & bare.
And their ways are fill'd with thorns
It is eternal winter there.

For where-e'er the sun does shine.
And where-e'er the rain does fall:
Babe can never hunger there,
Nor poverty the mind appall.

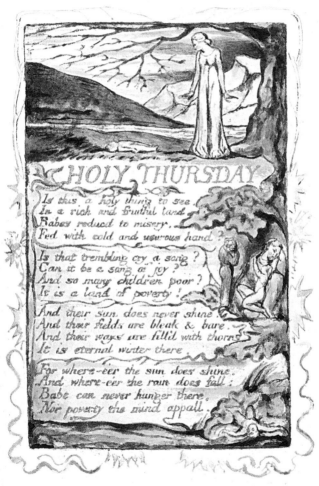

# HOLY THURSDAY

Is this a holy thing to see,
In a rich and fruitful land,
Babes reduced to misery,
Fed with cold and usurous hand?

Is that trembling cry a song?
Can it be a song of joy?
And so many children poor?
It is a land of poverty!

And their sun does never shine,
And their fields are bleak & bare,
And their ways are filled with thorns
It is eternal winter there.

For where-e'er the sun does shine,
And where-e'er the rain does fall:
Babe can never hunger there,
Nor poverty the mind appall.

*The Little Girl Lost*

In futurity
I prophetic see.
That the earth from sleep.
(Grave the sentence deep)

Shall arise and seek
For her maker meek:
And the desart wild
Become a garden mild.

In the southern clime,
Where the summers prime.
Never fades away;
Lovely Lyca lay.

Seven summers old
Lovely Lyca told,
She had wanderd long.
Hearing wild birds song.

Sweet sleep come to me
Underneath this tree;
Do father, mother weep.—
"Where can Lyca sleep".

Lost in desart wild
Is your little child.
How can Lyca sleep.
If her mother weep.

If her heart does ake.
Then let Lyca wake;
If my mother sleep,
Lyca shall not weep.

Frowning frowning night,
O'er this desart bright.
Let thy moon arise.
While I close my eyes.

Sleeping Lyca lay:
While the beasts of prey,
Come from caverns deep,
View'd the maid asleep

The kingly lion stood
And the virgin view'd,
Then he gambold round
O'er the hallowd ground:
*Leo[pard]s*

34

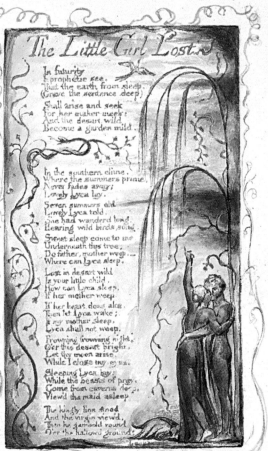

# The Little Girl Lost

In futurity
I prophetic see,
That the earth from sleep
(Grave the sentence deep)

Shall arise and seek
For her maker meek;
And the desart wild
Become a garden mild.

In the southern clime,
Where the summers prime,
Never fades away;
Lovely Lyca lay.

Seven summers old
Lovely Lyca told,
She had wanderd long,
Hearing wild birds song.

Sweet sleep come to me
Underneath this tree;
Do father, mother weep.—
Where can Lyca sleep.

Lost in desart wild
Is your little child.
How can Lyca sleep,
If her mother weep.

If her heart does ake,
Then let Lyca wake;
If my mother sleep,
Lyca shall not weep.

Frowning frowning night,
O'er this desart bright,
Let thy moon arise,
While I close my eyes.

Sleeping Lyca lay;
While the beasts of prey,
Come from caverns deep,
View'd the maid asleep

The kingly lion stood
And the virgin view'd,
Then he gambold round
O'er the hallowd ground

Leopards, tygers play,
Round her as she lay;
While the lion old,
Bow'd his mane of gold,

And her bosom lick,
And upon her neck,
From his eyes of flame,
Ruby tears there came;

*The Little Girl Found*

While the lioness,
Loos'd her slender dress,
And naked they convey'd
To caves the sleeping maid.

All the night in woe,
Lyca's parents go:
Over vallies deep.
While the desarts weep.

Tired and woe-begone.
Hoarse with making moan:
Arm in arm seven days.
They trac'd the desart ways.

Seven nights they sleep.
Among shadows deep:
And dream they see their child
Starv'd in desert wild.

Pale thro' pathless ways
The fancied image strays.

*Famish'd*

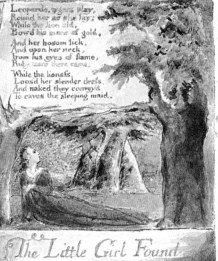

Leopards, tygers play,
Round her as she lay;
While the lion old,
Bow'd his mane of gold.

And her bosom lick,
And upon her neck,
From his eyes of flame,
Ruby tears there came;

While the lioness,
Loos'd her slender dress,
And naked they convey'd
To caves the sleeping maid.

## The Little Girl Found

All the night in woe,
Lyca's parents go:
Over vallies deep,
While the desarts weep.

Tired and woe begone,
Hoarse with making moan:
Arm in arm seven days,
They trac'd the desart ways.

Seven nights they sleep,
Among shadows deep:
And dream they see their child
Starv'd in desart wild.

Pale thro' pathless ways
The fancied image strays,

Famish'd, weeping, weak
With hollow piteous shriek

Rising from unrest,
The trembling woman prest,
With feet of weary woe;
She could no further go.

In his arms he bore.
Her arm'd with sorrow sore:
Till before their way,
A couching lion lay.

They look upon his eyes
Fill'd with deep surprise:
And wondering behold.
A spirit arm'd in gold.

Turning back was vain,
Soon his heavy mane.
Bore them to the ground;
Then he stalk'd around.

On his head a crown
On his shoulders down,
Flow'd his golden hair.
Gone was all their care.

Smelling to his prey,
But their fears allay.
When he licks their hands:
And silent by them stands.

Follow me he said,
Weep not for the maid;
In my palace deep.
Lyca lies asleep.

Then they followed,
Where the vision led;
And saw their sleeping child,
Among tygers wild.

To this day they dwell
In a lonely dell
Nor fear the wolvish howl,
Nor the lions growl.

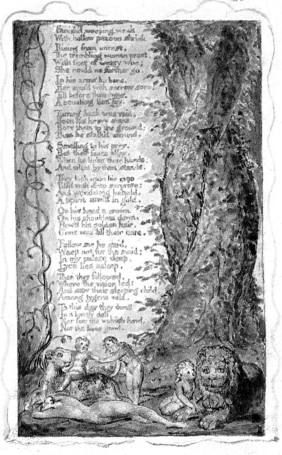

Famish'd, weeping, weak
With hollow piteous shriek

Rising from unrest,
The trembling woman prest,
With feet of weary woe;
She could no further go.

In his arms he bore,
Her arm'd with sorrow sore,
Till before their way,
A couching lion lay.

Turning back was vain,
Soon his heavy mane
Bore them to the ground;
Then he stalk'd around.

Smelling to his prey,
But their fears allay,
When he licks their hands,
And silent by them stands.

They look upon his eyes
Fill'd with deep surprize;
And wondering behold,
A spirit arm'd in gold.

On his head a crown,
On his shoulders down,
Flow'd his golden hair,
Gone was all their care.

Follow me he said,
Weep not for the maid;
In my palace deep,
Lyca lies asleep.

Then they followed,
Where the vision led:
And saw their sleeping child
Among tygers wild.

To this day they dwell
In a lonely dell,
Nor fear the wolvish howl,
Nor the lions growl.

*THE Chimney Sweeper*

A little black thing among the snow:
Crying weep, weep, in notes of woe!
Where are thy father & mother? say?
They are both gone up to the church to pray.

Because I was happy upon the heath.
And smil'd among the winters snow:
They clothed me in the clothes of death.
And taught me to sing the notes of woe.

And because I am happy. & dance & sing.
They think they have done me no injury:
And are gone to praise God & his Priest & King
Who make up a heaven of our misery.

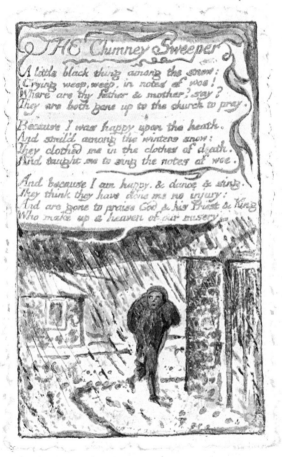

# THE Chimney Sweeper

A little black thing among the snow:
Crying weep, weep, in notes of woe!
Where are thy father & mother? say?
They are both gone up to the church to pray.

Because I was happy upon the heath.
And smil'd among the winters snow:
They clothed me in the clothes of death.
And taught me to sing the notes of woe.

And because I am happy. & dance & sing.
They think they have done me no injury:
And are gone to praise God & his Priest & King
Who make up a heaven of our misery.

*NURSES Song*

When the voices of children. are heard on the green
And whisprings are in the dale:
The days of my youth rise fresh in my mind,
My face turns green and pale.

Then come home my children. the sun is gone down
And the dews of night arise
Your spring & your day. are wasted in play
And your winter and night in disguise.

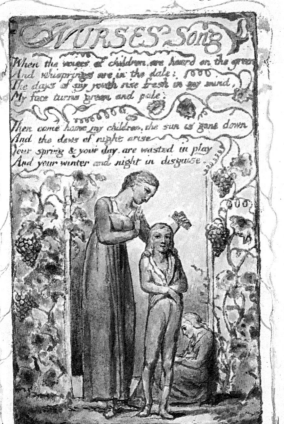

# NURSES Song

When the voices of children are heard on the green
And whisprings are in the dale:
The days of my youth rise fresh in my mind,
My face turns green and pale.

Then come home my children, the sun is gone down
And the dews of night arise
Your spring & your day, are wasted in play
And your winter and night in disguise.

## The SICK ROSE

O Rose thou art sick.
The invisible worm.
That flies in the night
In the howling storm:

Has found out thy bed
Of crimson joy:
And his dark secret love
Does thy life destroy.

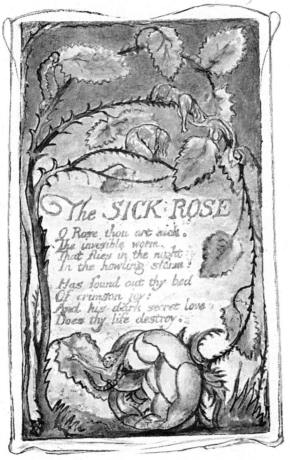

# The SICK ROSE

O Rose thou art sick.
The invisible worm,
That flies in the night
In the howling storm:

Has found out thy bed
Of crimson joy:
And his dark secret love
Does thy life destroy.

*THE FLY.*

Little Fly
Thy summers play,
My thoughtless hand
Has brush'd away.

Am not I
A fly like thee?
Or art not thou
A man like me?

For I dance
And drink & sing;
Till some blind hand
Shall brush my wing.

If thought is life
And strength & breath;
And the want
Of thought is death;

Then am I
A happy fly,
If I live,
Or if I die.

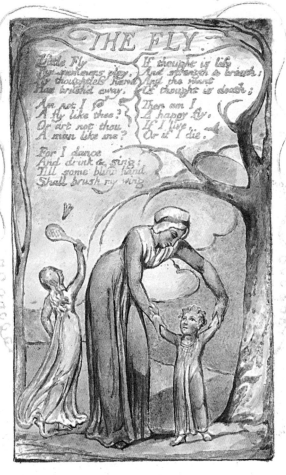

# THE FLY.

Little Fly
Thy summers play,
My thoughtless hand
Has brush'd away.

Am not I
A fly like thee?
Or art not thou
A man like me?

For I dance
And drink & sing;
Till some blind hand
Shall brush my wing

If thought is life
And strength & breath:
And the want
Of thought is death;

Then am I
A happy fly,
If I live,
Or if I die.

## The Angel

I Dreamt a Dream! what can it mean?
And that I was a maiden Queen:
Guarded by an Angel mild;
Witless woe, was neer beguil'd!

And I wept both night and day
And he wip'd my tears away
And I wept both day and night
And hid from him my hearts delight

So he took his wings and fled:
Then the morn blush'd rosy red:
I dried my tears & armd my fears,
With ten thousand shields and spears.

Soon my Angel came again;
I was arm'd, he came in vain:
For the time of youth was fled
And grey hairs were on my head

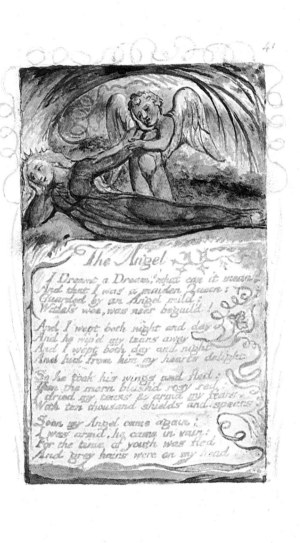

## The Angel

I Dreamt a Dream! what can it mean?
And that I was a maiden Queen:
Guarded by an Angel mild;
Witless woe, was neer beguil'd!

And I wept both night and day
And he wip'd my tears away
And I wept both day and night
And hid from him my hearts delight

So he took his wings and fled:
Then the morn blush'd rosy red;
I dried my tears & armd my fears,
With ten thousand shields and spears.

Soon my Angel came again;
I was arm'd, he came in vain:
For the time of youth was fled
And grey hairs were on my head

*The Tyger.*

Tyger Tyger. burning bright,
In the forests of the night;
What immortal hand or eye.
Could frame thy fearful symmetry?

In what distant deeps or skies.
Burnt the fire of thine eyes?
On what wings dare he aspire?
What the hand, dare sieze the fire?

And what shoulder, & what art,
Could twist the sinews of thy heart?
And when thy heart began to beat.
What dread hand? & what dread feet?

What the hammer? what the chain,
In what furnace was thy brain?
What the anvil? what dread grasp.
Dare its deadly terrors clasp?

When the stars threw down their spears
And water'd heaven with their tears:
Did he smile his work to see?
Did he who made the Lamb make thee?

Tyger Tyger burning bright,
In the forests of the night:
What immortal hand or eye,
Dare frame thy fearful symmetry?

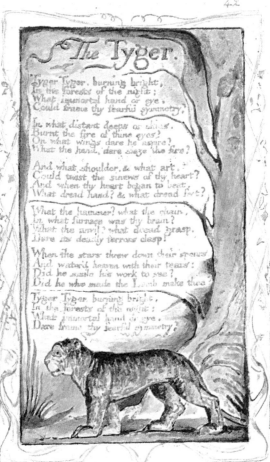

The Tyger.

Tyger Tyger, burning bright,
In the forests of the night;
What immortal hand or eye,
Could frame thy fearful symmetry?

In what distant deeps or skies,
Burnt the fire of thine eyes?
On what wings dare he aspire?
What the hand, dare seize the fire?

And what shoulder, & what art,
Could twist the sinews of thy heart?
And when thy heart began to beat,
What dread hand? & what dread feet?

What the hammer? what the chain,
In what furnace was thy brain?
What the anvil? what dread grasp,
Dare its deadly terrors clasp!

When the stars threw down their spears
And water'd heaven with their tears:
Did he smile his work to see?
Did he who made the Lamb make thee?

Tyger Tyger burning bright,
In the forests of the night:
What immortal hand or eye,
Dare frame thy fearful symmetry?

*My Pretty ROSE TREE*

A flower was offerd to me;
Such a flower as May never bore.
But I said I've a Pretty Rose-tree.
And I passed the sweet flower o'er.

Then I went to my Pretty Rose-tree:
To tend her by day and by night.
But my Rose turnd away with jealousy:
And her thorns were my only delight.

*AH! SUN-FLOWER*

Ah Sun-flower! weary of time.
Who countest the steps of the Sun:
Seeking after that sweet golden clime
Where the travellers journey is done.

Where the Youth pined away with desire,
And the pale Virgin shrouded in snow:
Arise from their graves and aspire.
Where my Sun-flower wishes to go.

*THE LILLY*

The modest Rose puts forth a thorn:
The humble Sheep. a threatning horn:
While the Lilly white, shall in Love delight,
Nor a thorn nor a threat stain her beauty bright

## My Pretty ROSE TREE

A flower was offer'd to me;
Such a flower as May never bore.
But I said I've a Pretty Rose-tree,
And I passed the sweet flower o'er.

Then I went to my Pretty Rose-tree:
To tend her by day and by night.
But my Rose turnd away with jealousy:
And her thorns were my only delight.

## AH! SUN-FLOWER

Ah Sun-flower! weary of time.
Who countest the steps of the Sun:
Seeking after that sweet golden clime
Where the travellers journey is done.

Where the Youth pined away with desire,
And the pale Virgin shrouded in snow:
Arise from their graves and aspire,
Where my Sun-flower wishes to go.

## THE LILLY

The modest Rose puts forth a thorn:
The humble Sheep, a threatning horn:
While the Lilly white, shall in Love delight,
Nor a thorn nor a threat stain her beauty bright.

*The GARDEN of LOVE*

I went to the Garden of Love.
And saw what I never had seen:
A Chapel was built in the midst,
Where I used to play on the green.

And the gates of this Chapel were shut,
And Thou shalt not, writ over the door;
So I turn'd to the Garden of Love,
That so many sweet flowers bore,

And I saw it was filled with graves,
And tomb-stones where flowers should be:
And Priests in black gowns, were walking their rounds,
And binding with briars, my joys & desires.

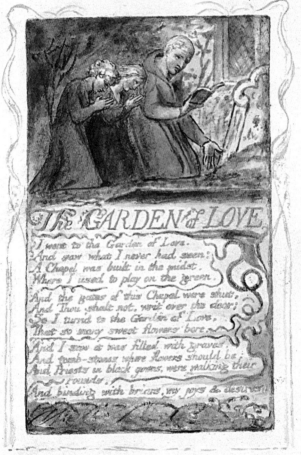

# THE GARDEN of LOVE.

I went to the Garden of Love,
And saw what I never had seen:
A Chapel was built in the midst,
Where I used to play on the green.

And the gates of this Chapel were shut,
And Thou shalt not, writ over the door;
So I turnd to the Garden of Love,
That so many sweet flowers bore.

And I saw it was filled with graves,
And tomb-stones where flowers should be;
And Priests in black gowns, were walking their
     rounds,
And binding with briars, my joys & desires.

*The Little Vagabond*

Dear Mother, dear Mother, the Church is cold,
But the Ale-house is healthy & pleasant & warm:
Besides I can tell where I am use'd well,
Such usage in heaven will never do well.

But if at the Church they would give us some Ale.
And a pleasant fire, our souls to regale:
We'd sing and we'd pray all the live-long day:
Nor ever once wish from the Church to stray.

Then the Parson might preach & drink & sing.
And we'd be as happy as birds in the spring:
And modest dame Lurch, who is always at Church
Would not have bandy children nor fasting nor birch

And God like a father rejoicing to see.
His children as pleasant and happy as he:
Would have no more quarrel with the Devil or the Barrel
But kiss him & give him both drink and apparel.

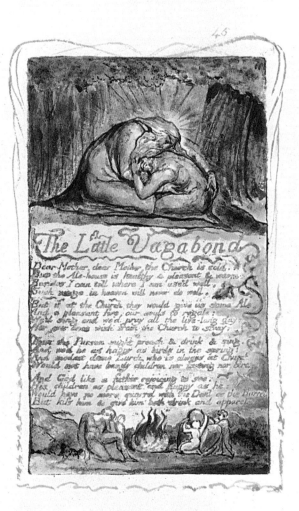

45

# The Little Vagabond

Dear Mother, dear Mother, the Church is cold,
But the Ale-house is healthy & pleasant & warm;
Besides I can tell where I am used well,
Such usage in heaven will never do well.

But if at the Church they would give us some Ale
And a pleasant fire, our souls to regale;
We'd sing and we'd pray all the live-long day;
Nor ever once wish from the Church to stray,

Then the Parson might preach & drink & sing,
And we'd be as happy as birds in the spring:
And modest dame Lurch, who is always at Church,
Would not have bandy children nor fasting nor birch.

And God like a father rejoicing to see,
His children as pleasant and happy as he:
Would have no more quarrel with the Devil or the Barrel,
But kiss him & give him both drink and apparel.

## LONDON

I wander thro' each charter'd street.
Near where the charter'd Thames does flow
And mark in every face I meet
Marks of weakness, marks of woe.

In every cry of every Man.
In every Infants cry of fear.
In every voice; in every ban.
The mind-forg'd manacles I hear

How the Chimney-sweepers cry
Every blackning Church appalls.
And the hapless Soldiers sigh
Runs in blood down Palace walls

But most thro' midnight streets I hear
How the youthful Harlots curse
Blasts the new-born Infants tear
And blights with plagues the Marriage hearse

# LONDON

I wander thro' each charter'd street.
Near where the charter'd Thames does flow
And mark in every face I meet
Marks of weakness, marks of woe.

In every cry of every Man,
In every Infants cry of fear,
In every voice; in every ban,
The mind-forg'd manacles I hear

How the Chimney-sweepers cry
Every blackning Church appalls.
And the hapless Soldiers sigh
Runs in blood down Palace walls

But most thro' midnight streets I hear
How the youthful Harlots curse
Blasts the new born Infants tear
And blights with plagues the Marriage hearse

*The Human Abstract.*

Pity would be no more,
If we did not make somebody Poor;
And Mercy no more could be.
If all were as happy as we;

And mutual fear brings peace;
Till the selfish loves increase.
Then Cruelty knits a snare,
And spreads his baits with care.

He sits down with holy fears.
And waters the ground with tears:
Then Humility takes its root
Underneath his foot.

Soon spreads the dismal shade
Of Mystery over his head;
And the Catterpiller and Fly.
Feed on the Mystery.

And it bears the fruit of Deceit.
Ruddy and sweet to eat:
And the Raven his nest has made
In its thickest shade.

The Gods of the earth and sea,
Sought thro' Nature to find this Tree
But their search was all in vain:
There grows one in the Human Brain

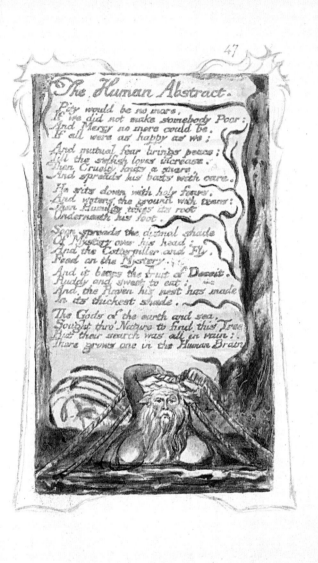

# The Human Abstract.

Pity would be no more,
If we did not make somebody Poor:
And Mercy no more could be,
If all were as happy as we;

And mutual fear brings peace;
Till the selfish loves increase.
Then Cruelty knits a snare,
And spreads his baits with care.

He sits down with holy fears,
And waters the ground with tears:
Then Humility takes its root
Underneath his foot.

Soon spreads the dismal shade
Of Mystery over his head;
And the Catterpiller and Fly,
Feed on the Mystery.

And it bears the fruit of Deceit,
Ruddy and sweet to eat;
And the Raven his nest has made
In its thickest shade.

The Gods of the earth and sea,
Sought thro' Nature to find this Tree
But their search was all in vain:
There grows one in the Human Brain

## INFANT SORROW

My mother groand! my father wept,
Into the dangerous world I leapt:
Helpless, naked, piping loud:
Like a fiend hid in a cloud.

Struggling in my fathers hands:
Striving against my swadling bands:
Bound and weary I thought best
To sulk upon my mothers breast.

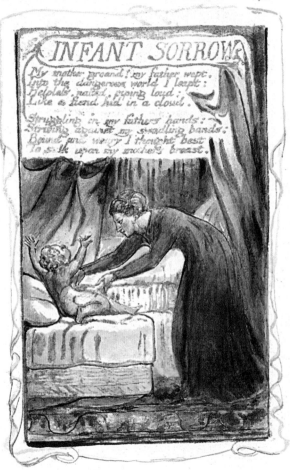

# INFANT SORROW

My mother groand! my father wept.
Into the dangerous world I leapt:
Helpless, naked, piping loud;
Like a fiend hid in a cloud.

Struggling in my fathers hands;
Striving against my swadling bands;
Bound and weary I thought best
To sulk upon my mothers breast.

## A POISON TREE.

I was angry with my friend;
I told my wrath, my wrath did end.
I was angry with my foe:
I told it not. my wrath did grow.

And I waterd it in fears,
Night & morning with my tears:
And I sunned it with smiles,
And with soft deceitful wiles.

And it grew both day and night,
Till it bore an apple bright.
And my foe beheld it shine,
And he knew that it was mine.

And into my garden stole.
When the night had veild the pole;
In the morning glad I see,
My foe outstretchd beneath the tree.

49

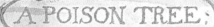

# A POISON TREE;

I was angry with my friend:
I told my wrath, my wrath did end.
I was angry with my foe:
I told it not, my wrath did grow.

And I waterd it in fears,
Night & morning with my tears:
And I sunned it with smiles,
And with soft deceitful wiles.

And it grew both day and night.
Till it bore an apple bright,
And my foe beheld it shine,
And he knew that it was mine.

And into my garden stole,
When the night had veild the pole;
In the morning glad I see;
My foe outstretchd beneath the tree.

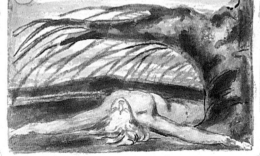

## A Little BOY Lost

Nought loves another as itself
Nor venerates another so.
Nor is it possible to Thought
A greater than itself to know:

And Father. how can I love you,
Or any of my brothers more?
I love you like the little bird
That picks up crumbs around the door.

The Priest sat by and heard the child,
In trembling zeal he siez'd his hair:
He led him by his little coat:
And all admir'd the Priestly care.

And standing on the altar high.
Lo what a fiend is here! said he:
One who sets reason up for judge
Of our most holy Mystery.

The weeping child could not be heard,
The weeping parents wept in vain:
They strip'd him to his little shirt.
And bound him in an iron chain.

And burn'd him in a holy place.
Where many had been burn'd before:
The weeping parents wept in vain.
Are such things done on Albions shore.

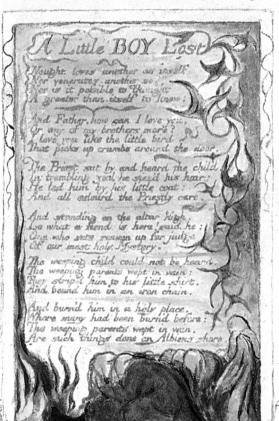

## A Little BOY Lost

Nought loves another as itself
Nor venerates another so.
Nor is it possible to Thought
A greater than itself to know:

And Father, how can I love you,
Or any of my brothers more?
I love you like the little bird
That picks up crumbs around the door.

The Priest sat by and heard the child.
In trembling zeal he siezd his hair:
He led him by his little coat:
And all admird the Priestly care.

And standing on the altar high,
Lo what a fiend is here! said he:
One who sets reason up for judge
Of our most holy Mystery.

The weeping child could not be heard.
The weeping parents wept in vain:
They stripd him to his little shirt.
And bound him in an iron chain.

And burnd him in a holy place,
Where many had been burnd before:
The weeping parents wept in vain.
Are such things done on Albions shore

*A Little GIRL Lost*

Children of the future Age.
Reading this indignant page;
Know that in a former time.
Love! sweet Love! was thought a crime.

In the Age of Gold,
Free from winters cold:
Youth and maiden bright.
To the holy light,
Naked in the sunny beams
           delight.

Tired with kisses sweet
They agree to meet,
When the silent sleep
Waves o'er heavens deep:
And the weary tired wanderers
           weep.

Once a youthful pair
Fill'd with softest care;
Met in garden bright.
Where the holy light,
Had just removd the curtains
           of the night.

To her father white
Came the maiden bright:
But his loving look,
Like the holy book,
All her tender limbs with terror
           shook

There in rising day.
On the grass they play:
Parents were afar;
Strangers came not near:
And the maiden soon forgot
           her fear.

Ona! pale and weak!
To thy father speak:
O the trembling fear!
O the dismal care!
That shakes the blossoms of my
           hoary hair

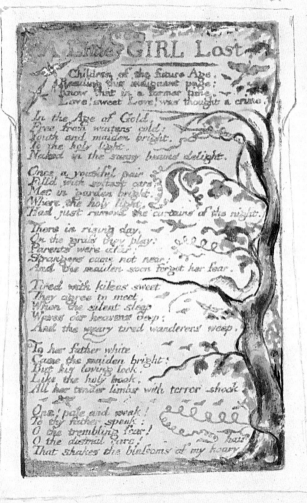

# A Little GIRL Lost

Children of the future Age.
Reading this indignant page;
Know that in a former time,
Love! sweet Love! was thought a crime.

In the Age of Gold,
Free from winters cold:
Youth and maiden bright,
To the holy light,
Naked in the sunny beams delight.

Once a youthful pair
Fill'd with softest care:
Met in garden bright,
Where the holy light,
Had just removd the curtains of the night.

There in rising day,
On the grass they play:
Parents were afar:
Strangers came not near:
And the maiden soon forgot her fear.

Tired with kisses sweet
They agree to meet,
When the silent sleep
Waves o'er heavens deep;
And the weary tired wanderers weep.

To her father white
Came the maiden bright:
But his loving look,
Like the holy book,
All her tender limbs with terror shook.

Ona! pale and weak!
To thy father speak:
O the trembling fear!
O the dismal care!
That shakes the blossoms of my hoary

*To Tirzah*

Whate'er is Born of Mortal Birth,
Must be consumed with the Earth
To rise from Generation free:
Then what have I to do with thee?

The Sexes sprung from Shame & Pride
Blowd in the morn; in evening died
But Mercy changd Death into Sleep;
The Sexes rose to work & weep.

Thou Mother of my Mortal part.
With cruelty didst mould my Heart.
And with false self-decieving tears.
Didst bind my Nostrils Eyes & Ears

Didst close my Tongue in senseless clay
And me to Mortal Life betray:
The Death of Jesus set me free.
Then what have I to do with thee?

      It is Raised
       a Spiritual Body

# To Tirzah

Whate'er is Born of Mortal Birth,
Must be consumed with the Earth
To rise from Generation free;
Then what have I to do with thee?

The Sexes sprung from Shame & Pride
Blow'd in the morn; in evening died
But Mercy changd Death into Sleep;
The Sexes rose to work & weep.

Thou, Mother of my Mortal part.
With cruelty didst mould my Heart.
And with false self-decieving tears
Didst bind my Nostrils Eyes & Ears

Didst close my Tongue in senseless clay
And me to Mortal Life betray:
The Death of Jesus set me free,
Then what have I to do with thee?

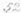

It is Raised
a Spiritual Body

## The School Boy

I love to rise in a summer morn,
When the birds sing on every tree;
The distant huntsman winds his horn,
And the sky-lark sings with me.
O! what sweet company.

But to go to school in a summer morn,
O! it drives all joy away;
Under a cruel eye outworn.
The little ones spend the day,
In sighing and dismay.

Ah! then at times I drooping sit,
And spend many an anxious hour,
Nor in my book can I take delight,
Nor sit in learnings bower,
Worn thro' with the dreary shower.

How can the bird that is born for joy,
Sit in a cage and sing.
How can a child when fears annoy.
But droop his tender wing.
And forget his youthful spring.

O! father & mother. if buds are nip'd,
And blossoms blown away,
And if the tender plants are strip'd
Of their joy in the springing day,
By sorrow and cares dismay.

How shall the summer arise in joy.
Or the summer fruits appear.
Or how shall we gather what griefs destroy
Or bless the mellowing year.
When the blasts of winter appear.

# The School Boy

I love to rise in a summer morn,
When the birds sing on every tree;
The distant huntsman winds his horn,
And the sky-lark sings with me.
O! what sweet company.

But to go to school in a summer morn,
O! it drives all joy away;
Under a cruel eye outworn,
The little ones spend the day,
In sighing and dismay.

Ah! then at times I drooping sit,
And spend many an anxious hour,
Nor in my book can I take delight,
Nor sit in learnings bower,
Worn thro' with the dreary shower.

How can the bird that is born for joy,
Sit in a cage and sing,
How can a child when fears annoy,
But droop his tender wing,
And forget his youthful spring.

O! father & mother, if buds are nip'd,
And blossoms blown away,
And if the tender plants are strip'd
Of their joy in the springing day,
By sorrow and cares dismay,

How shall the summer rise in joy,
Or the summer fruits appear,
Or how shall we gather what griefs destroy
Or bless the mellowing year,
When the blasts of winter appear.

*The Voice of the Ancient Bard.*

Youth of delight come hither.
And see the opening morn,
Image of truth new born.
Doubt is fled & clouds of reason.
Dark disputes & artful teazing,
Folly is an endless maze,
Tangled roots perplex her ways,
How many have fallen there!
They stumble all night over bones of the dead:
And feel they know not what but care;
And wish to lead others when they should be led

# The Voice of the Ancient Bard.

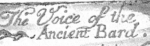

Youth of delight come hither,
And see the opening morn,
Image of truth new born.
Doubt is fled & clouds of reason,
Dark disputes & artful teazing.
Folly is an endless maze,
Tangled roots perplex her ways,
How many have fallen there!
They stumble all night over bones of the dead:
And feel they know not what but care;
And wish to lead others when they should be led.

Facsimile reproductions and text transcript, edited by Andrew Lincoln,
first published 1991, in Volume 2 of Blake's Illuminated Books, by Tate Gallery
Publications in association with the William Blake Trust

Small-format edition first published by The Folio Society Ltd 1992
44 Eagle Street, London WC1R 4FS
www.foliosociety.com

This edition first published 2006, by order of the Tate Trustees,
by Tate Publishing, a division of Tate Enterprises Ltd
Millbank, London SW1P 4RG
www.tate.org.uk/publishing
in association with the William Blake Trust

Reprinted 2007, 2008, 2009, 2010, 2011, 2012, 2013, 2014, 2016, 2018, 2019, 2022

British Library Cataloguing in Publication Data
A catalogue record for this book is available from the British Library

ISBN 978-185437-729-6

Distributed in the United States and Canada
by Harry N. Abrams, Inc., New York

Library of Congress Cataloging in Publication Data
Library of Congress Control Number applied for

Typeset by Studio Lorenz Klingebiel
Colour reproduction by DL Imaging, London
Printed and bound by Pigini Group – Printing Division, Italy